Tell Me What You See

visual writing prompts for the wandering writer

ONE IDEA

PRESS

Tell Me What You See

To contact the publisher, visit www.OneIdeaPress.com

ISBN-13: 978-1-944134-14-3

Printed in the United States of America

TELL ME WHAT YOU SEE

visual prompts
for the wandering writer

Caroline Topperman

What's the *story* behind this photograph?

The second you ask anyone that question, a million things come to mind. Sounds simple, right? Yet, as writers, we often find ourselves sitting and staring at a blank page for hours on end, or doing everything but trying to write because we find ourselves without the words or ideas. This can be extremely frustrating, and because our work is often solitary, it means that we spend a lot of our day procrastinating and losing hope in our literary pursuits.

It doesn't have to be that way. Sometimes, it's about

changing the way we approach writing.

We enroll in writing courses and work constantly on honing our craft, which is necessary to evolve and improve, but I find that it is often at the expense of being in the moment and acutely aware of our surroundings. We are so good at creating imaginary worlds, but what about the beauty and wonder of the world we live in?

Writing is not just about words on a page. Whether you are writing a personal essay, a short story or a an entire series, the goal is to have your reader lose themselves for even a brief moment. You want them to use all of their senses. How a character moves through life, how a story unfolds and jumps off the page—it's all about drawing a reader into your tale so that they, too, can picture the characters, can feel the emotions, can smell the surroundings. All of this is accomplished by the power of visual descriptions. What better way to find those visuals than by simply stopping and looking around? We are often taught to write what we know and how better to do that than to describe what we are seeing? There is a three-dimensional world right outside your door.

While it can be argued that there isn't a whole story in every single thing we see, what you will find is that by learning to notice how that leaf flutters gently in a breeze, how that blue rickety wooden door doesn't quite fit its frame, or how the paint makes a pattern on the weather-beaten building down the street, your writing will become much richer. Not only that, but these visual writing prompts will facilitate story ideas where and when you least expect them. Imagine how great it would be to be brimming with

story ideas all the time. Remember that a book, before it is polished and edited, is often raw and can begin at any point in the story.

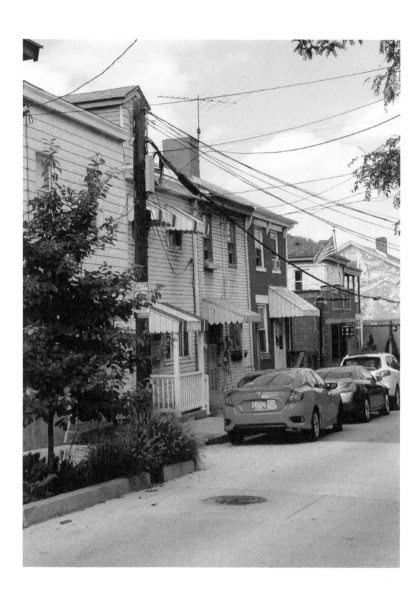

A day on the typical downtown street?
Maybe. Who are the people that reside here?

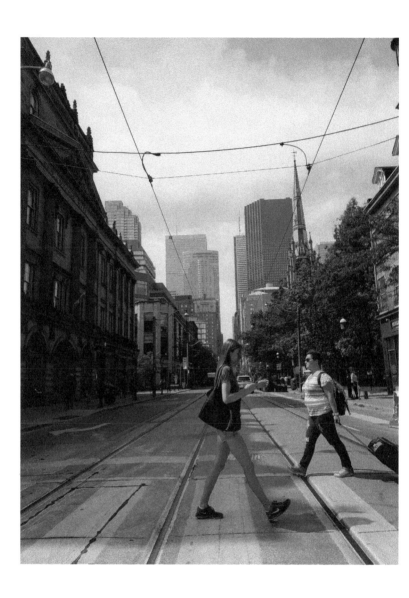

Two women passing on a busy street.
You see them as you drive by.
They glance at each other and a conversation ensues.
What do they say?

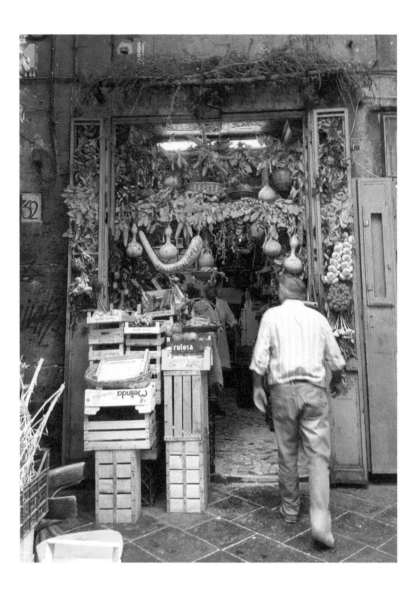

There are some places in the world that lend themselves to finding just the right ingredients. How far will you go to get the perfect spices?

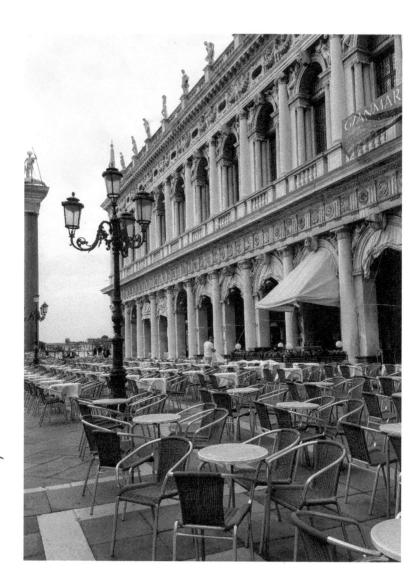

An empty café first thing in the morning.
You haven't slept all night,
and what you really want is a coffee.
What did you do last night?

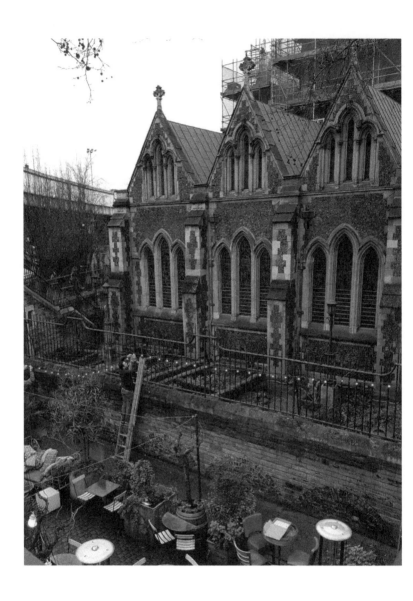

When the sun sets and the twinkle lights sparkle in the night, a seemingly ordinary café suddenly becomes the setting for a romance. You are sitting with a glass of wine, remembering the love of your life.
What was the story?

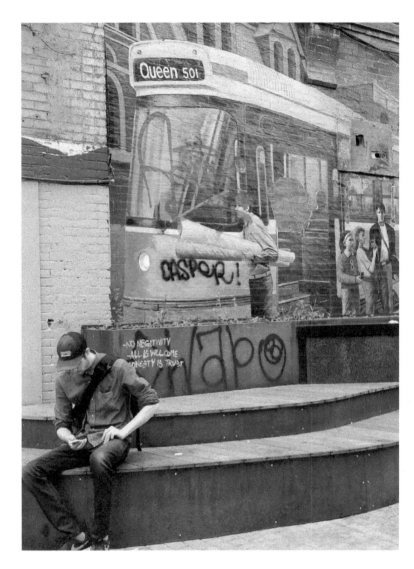

A trendy Toronto street and a famous icon forever imprinted on a wall. Who is the guy on his phone? Why did he choose this spot?

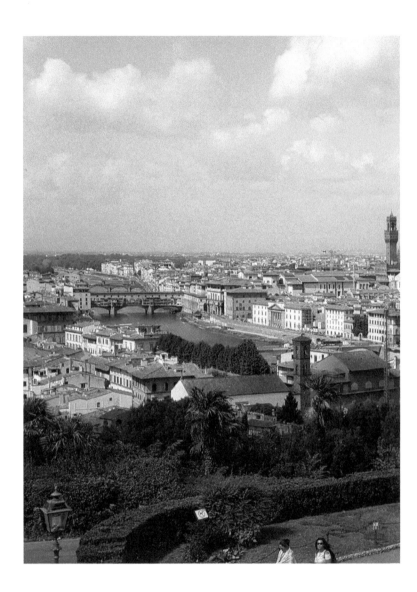

Sometimes it's necessary to step away
and take a break from all the city noise.
As you sit and gaze over Florence,
what are you thinking?

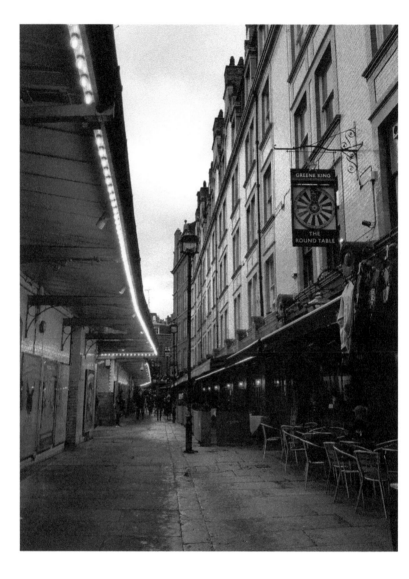

Seemingly deserted, or maybe just a quiet time during the day. Either way, sometimes it's best to get off the beaten track and turn down a random alley.
Who knows what you will find.

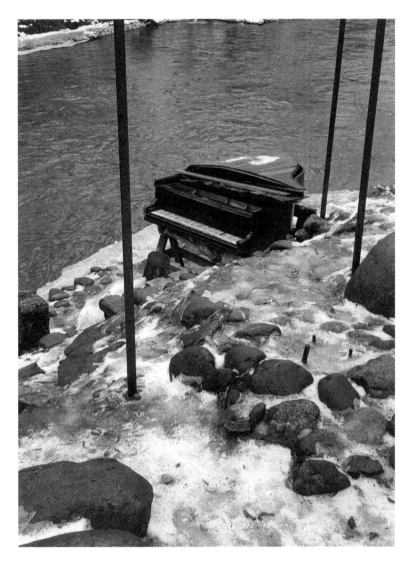

An artist's enclave in the middle of the city of Vilnius. They've declared themselves an independent country and have placed pianos in the most random of spots. Why?

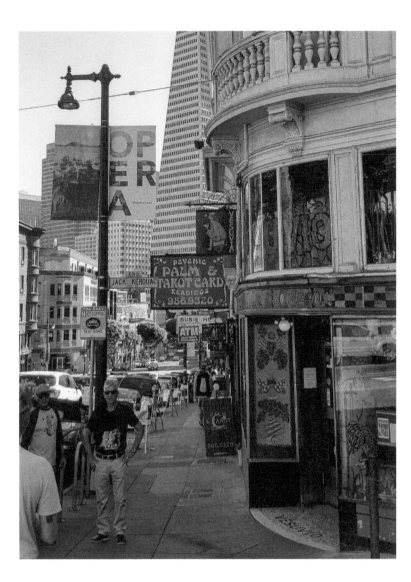

San Francisco, home to America's best and worst, but, regardless, there's always something exciting happening. Who is about to walk out that door?

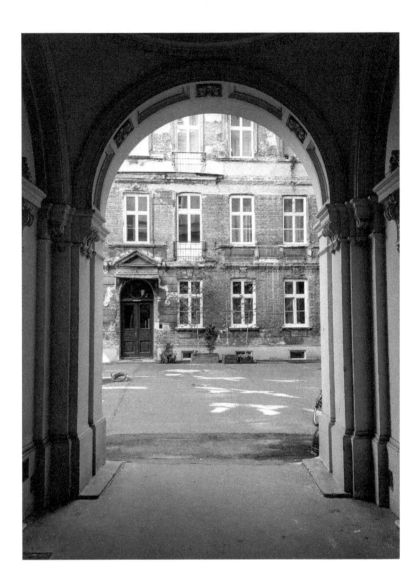

Warsaw is home to hundreds, if not thousands, of such courtyards. Some parts of the buildings are pre-war, others have been rebuilt and made to look old. All of these courtyards have a story to tell. This is one of the originals. Can you see the families that lived here?

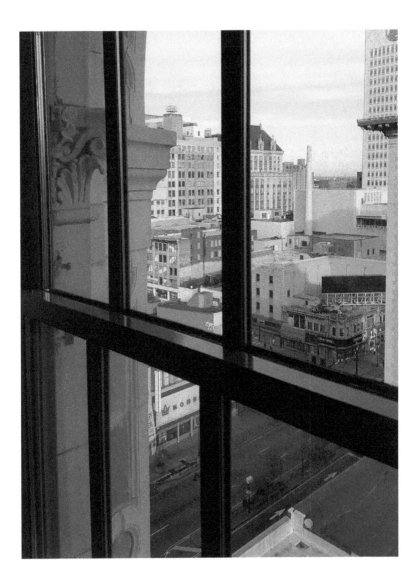

From the inside looking out. Newark. A city hit by the recession and still recovering. From your vantage point, you see many empty, boarded up buildings and storefronts. Imagine how the city will look in five, ten, or even fifteen years.

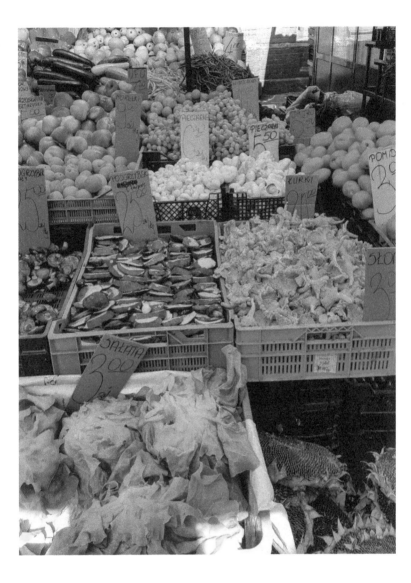

Saturday morning at the farmers market!
Grab your coffee, a fresh pastry, and a shopping bag.
Describe the sights, sounds, and smells.

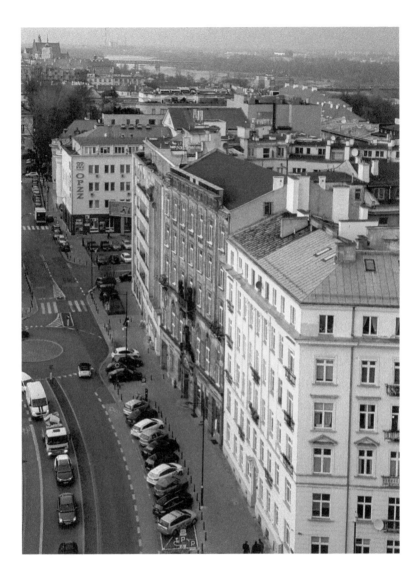

This is your new view. You make yourself a cup of coffee or tea and sit down at your writing desk. What are you writing about today?

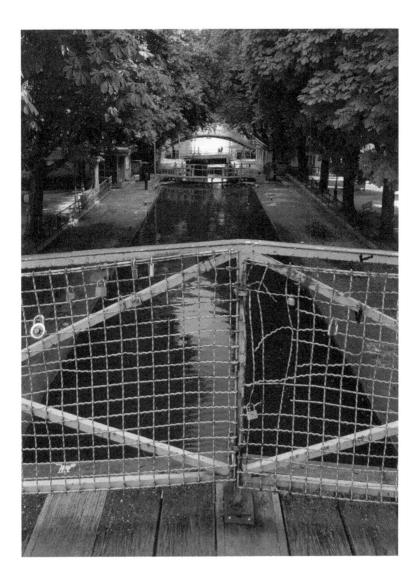

Some parts of Paris are made for social media photos and others are more representative of what the city really looks like. This is where you will find the locals. It's summer, you have a croissant in one hand and a notebook in the other. Have a seat, relax, and write down how you are feeling.

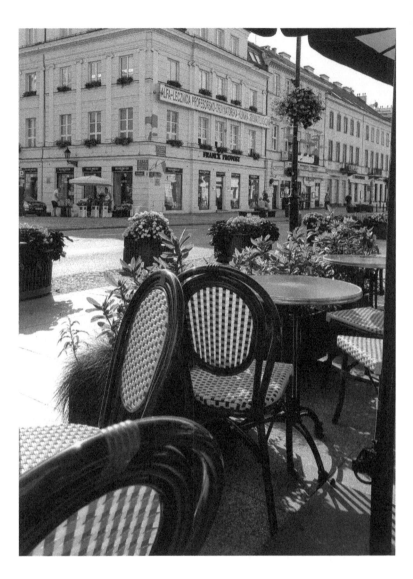

There are days when you just need to sit at a café and people watch. Who is walking by?

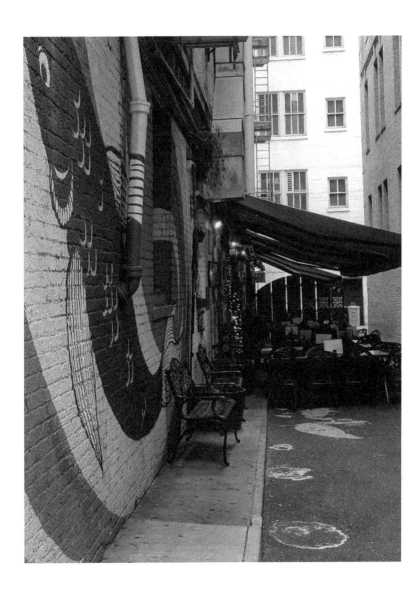

Is there anything better than finding a restaurant that is not mainstream? This is where the real foodies flock. How did you find it?

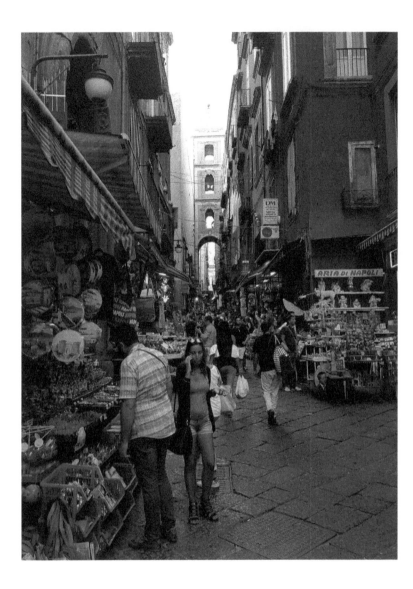

Naples is a city that epitomizes the word "heat." Its residents are fiery and spirited, and in the summer, you can feel the warmth emanating from the cobblestones. There is a rhythmic pulse in the air. Describe it.

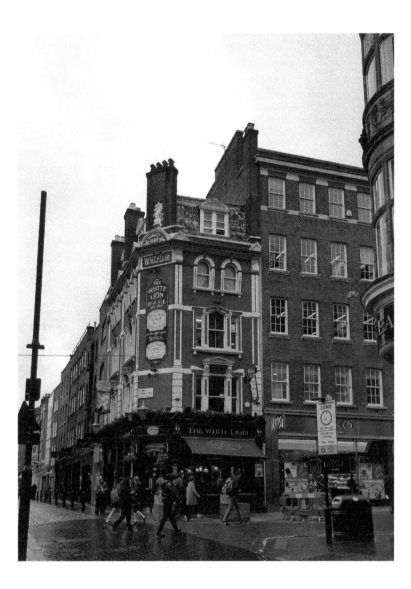

A rainy day in London, nothing out of the ordinary, or is it? What could possibly happen today that might change this scene forever?

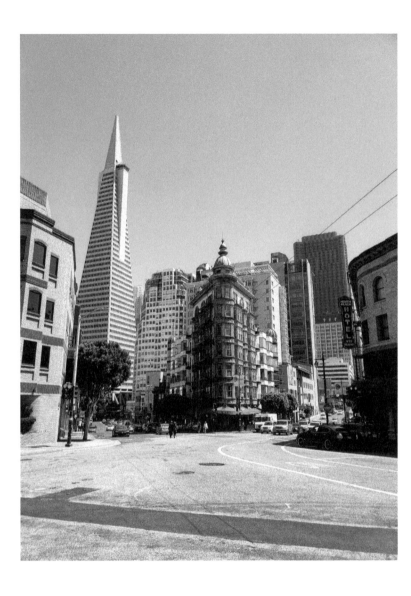

Downtown San Francisco is usually very busy and crowded. Why is it so empty today? Where is everyone?

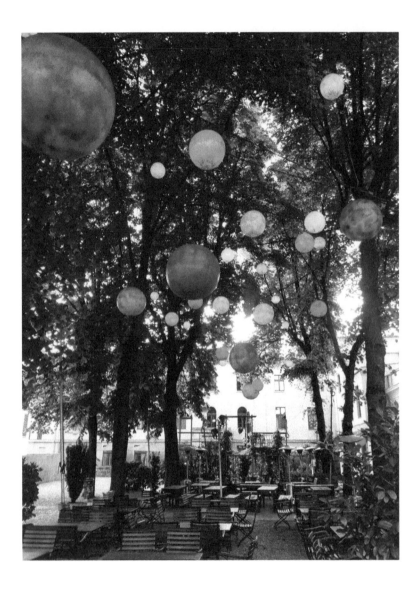

Cities like Berlin are a study in contrasts. East meets West is always a prevalent them, making it important to walk off the beaten path, because you never know what you will find. What is this beautiful garden?

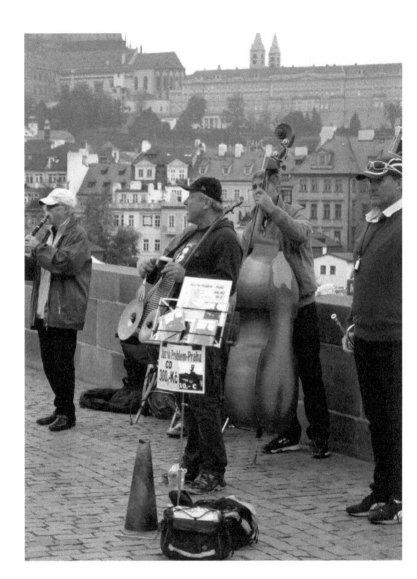

Prague. This is a group of first-rate musicians. They are real pros who love playing on the street. What do they do when they aren't bringing music to the people?

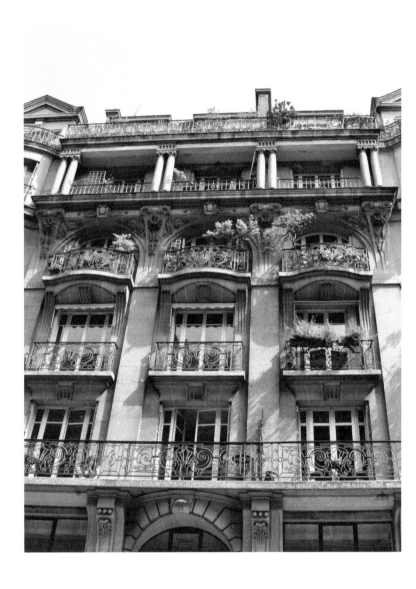

The beautiful balconies of Paris.
I see a love story unfolding on one of those floors.
What do you see?

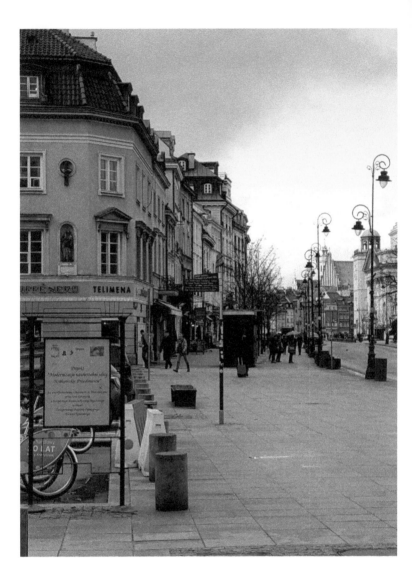

The Royal Route in Warsaw leads to Old Town. Pretend you are there. What do you think makes for a great Old Town? Describe the spirit, even if you have never been to one.

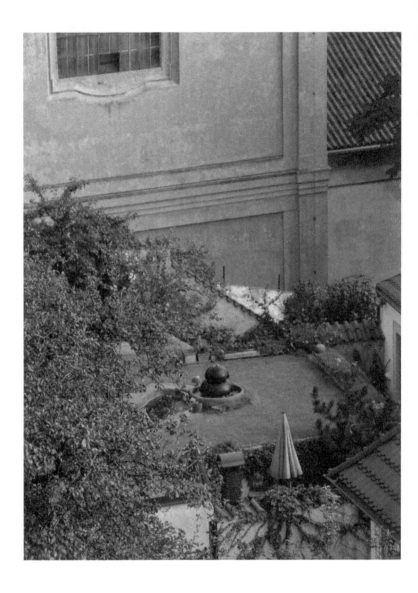

A hidden garden amongst the rooftops of Prague.
How did it come about?

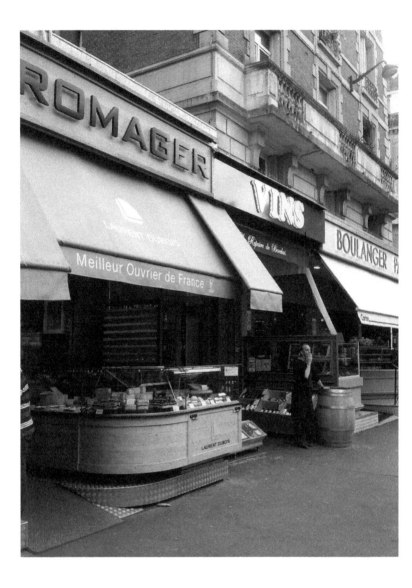

What could be more French than having a boulangerie (bakery), a vins (wine), and a fromager (cheese)shop all in one stop? All you need is a basket, some fresh flowers, and you are ready to go. It's like a scene out of the movies. Describe it and what follows.

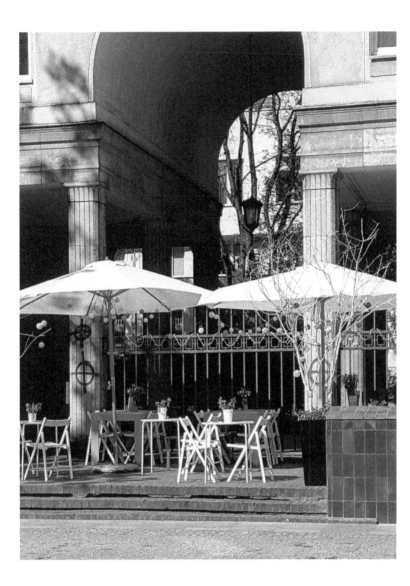

Summer is made for patios.
You are on your way to work.
Do you stop for a quick coffee to start your day?

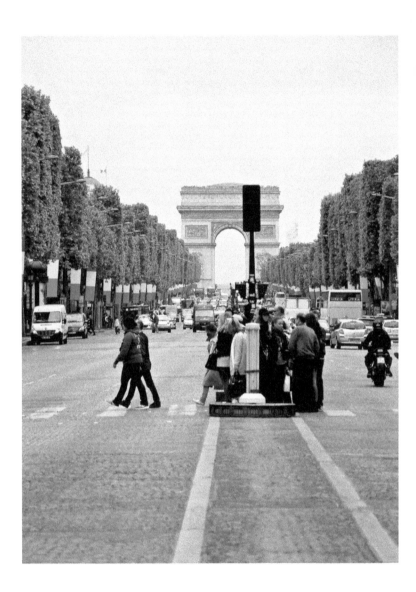

A French icon, the Arc de Triomphe, is mostly ignored by Parisians. What do you think it feels like to live in one of the most Instagramable cities in the world? How annoying are all those tourists?

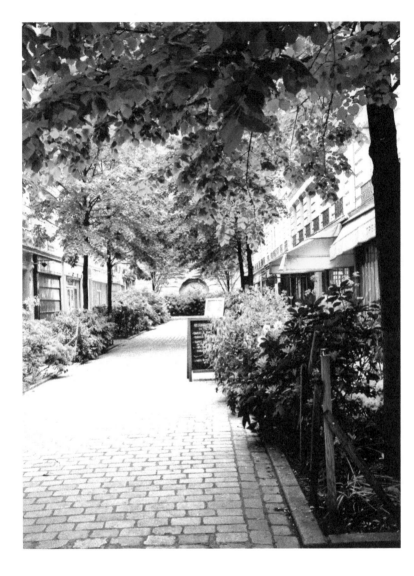

What could be better than a small side street filled with cafés and restaurants? This is exactly like the type of area all the great writers used to work in. Quick, what are you writing right now?

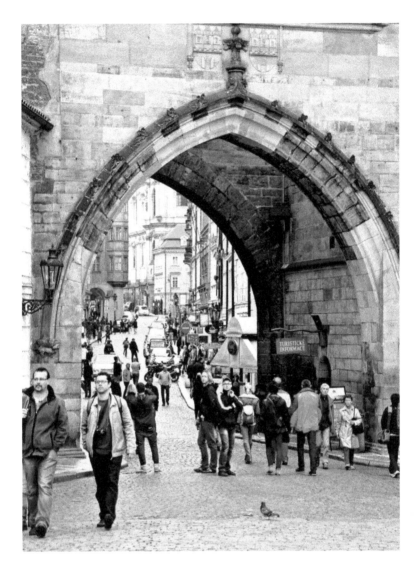

Prague.
See the two men to the front left of the photo?
Who do you think they are
and what are they doing here?

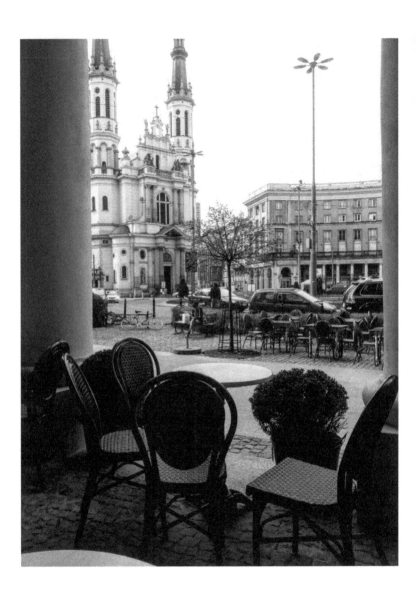

This is your vantage point for the next few days. How is this view going to inspire you?
What does it make you want to write about?

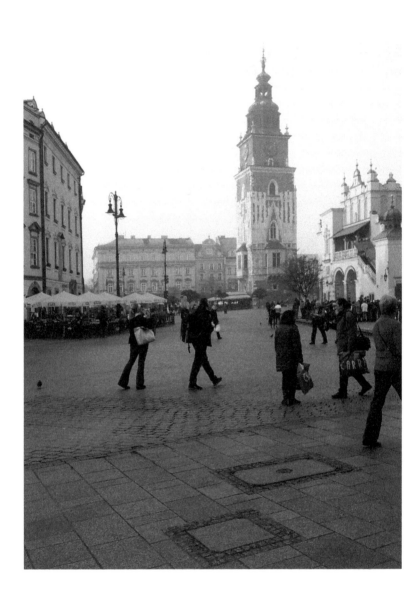

Krakow Old Town. The building you see on your right is a UNESCO world heritage site called Sukiennice, or Cloth Hall, which dates back to the Renaissance. In the fifteenth century, you could find textiles, leather, wax, and spices in its great hall. Describe the scene as it might have been back then.

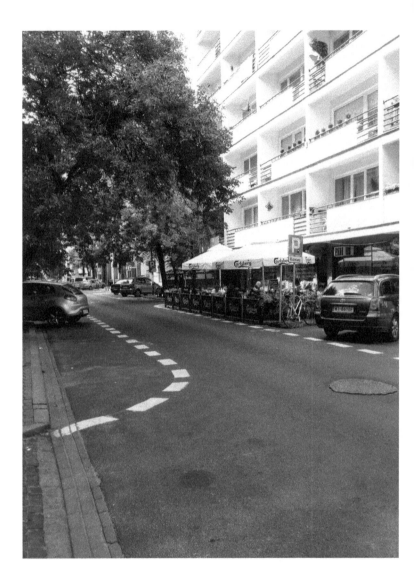

It may not be the most glamorous building, but you are living your dream of being a full-time writer. Do you go down to the café to write or do you prefer working at your craft somewhere else?

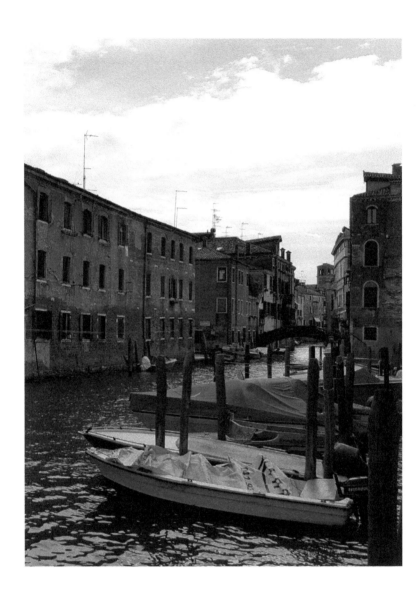

This is a part of Venice where tourists rarely venture. There are no fancy restaurants or trendy cafés. This is where people really live. Could you live like this? How would it be waking up on the rising water every day?

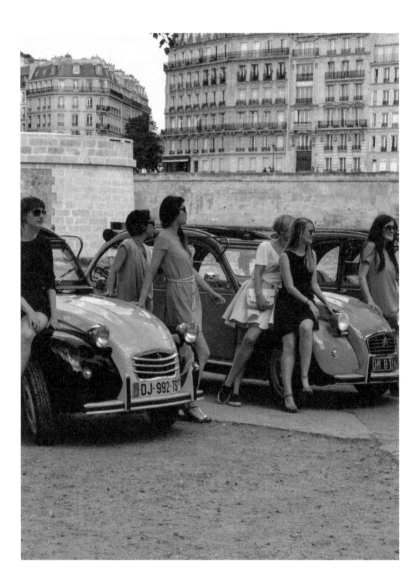

Vintage cars, young women dressed up and hanging out, what could possibly be going on here?
Just a magazine photo shoot, or something more fun?

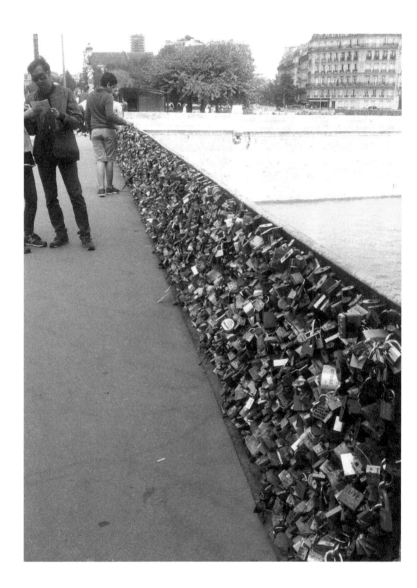

The famous padlock bridge in Paris.
In five-hundred words or less, write a love story.

Do you ever have one of those days when you want to move into a houseboat? Think about it: you'd have the freedom to travel the waterways and change your location as often as you want. What would a life like that be like?

This is the Ecole Des Beaux Arts in Paris, and it's where my mother studied painting. Take a moment to think about what your parents did in their youth. What were their hopes and dreams?

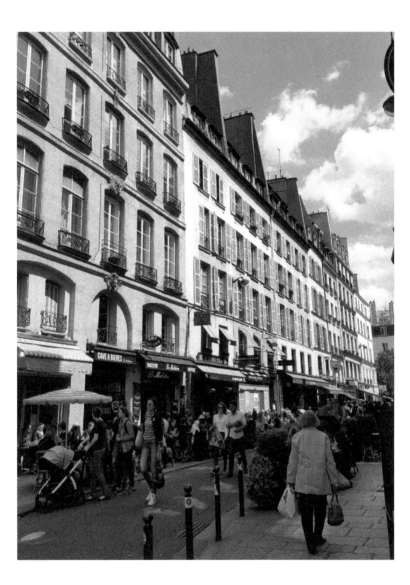

A busy street filled with restaurants and shoppers. Do you dive in enthusiastically and join them, or would you prefer to run away and find a deserted spot somewhere on the outskirts of town?
Does it inspire you or stifle you?

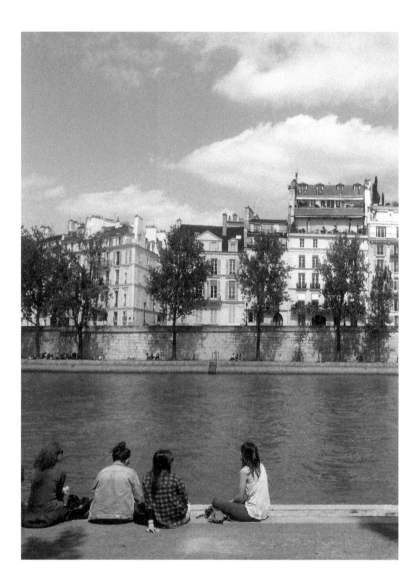

They may be separated by borders, by oceans or by mountains, but when it comes down to it, teenagers all over the world are kind of the same.
What is this group doing?

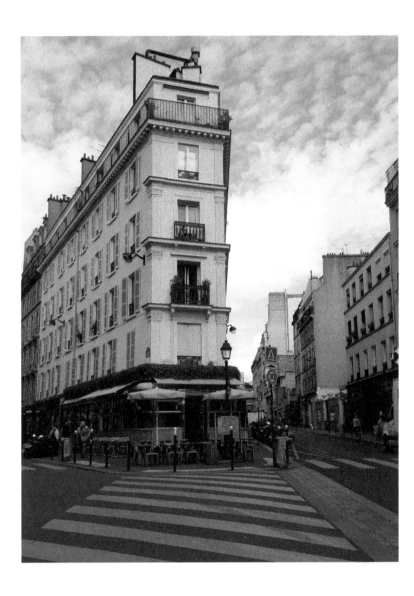

You are standing at the crosswalk.
Where to next?

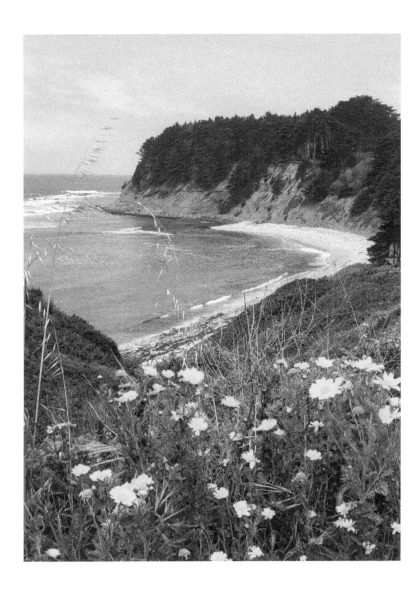

You hear the sound of crashing waves and wind in the trees. Take a deep breath and savor the sea salt in the air. What is the first thing you are going to do when you reach the beach down below?

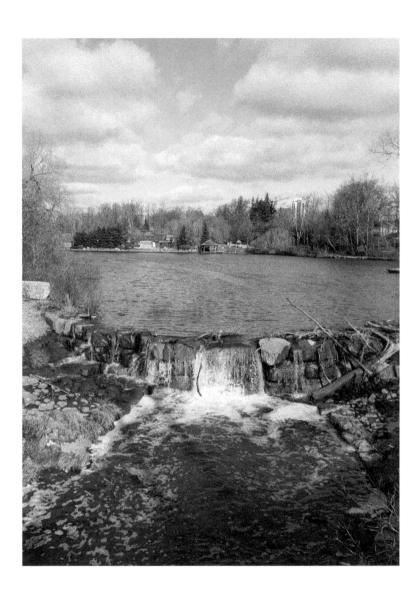

A waterfall in the city. Winter is nearing its end, and the first signs of spring are in the air.
How will you celebrate?

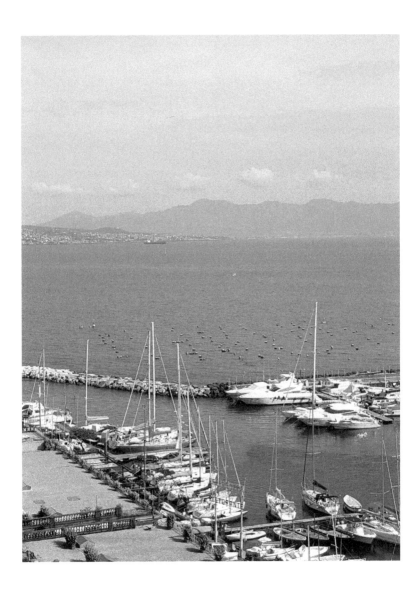

Close your eyes and feel the breeze of the
Mediterranean wafting delicately through your hair.
What do you see, hear, and feel?

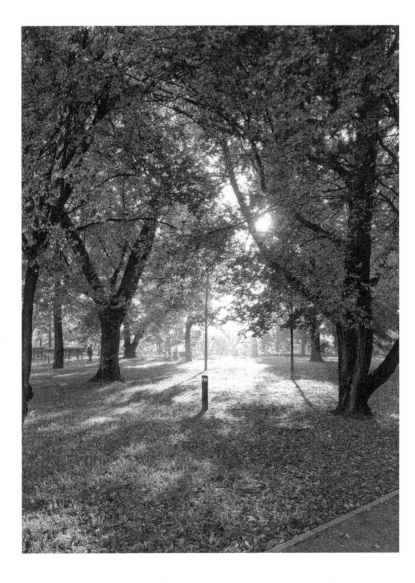

Early fall mornings.
The air is crisp, the leaves are turning gold and red.
Who do you see?

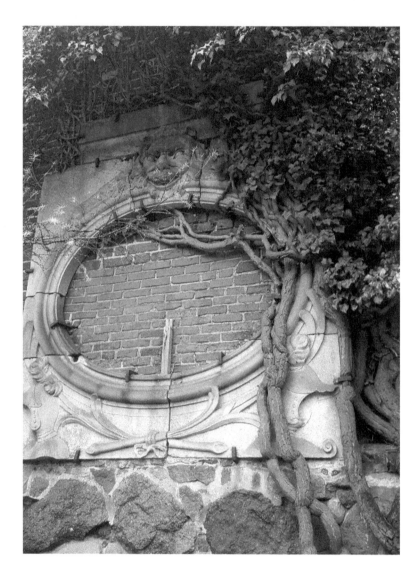

On the grounds of a UNESCO heritage castle, this wall can be found in the surrounding gardens. Was that brick wall always there, or is it hiding something?

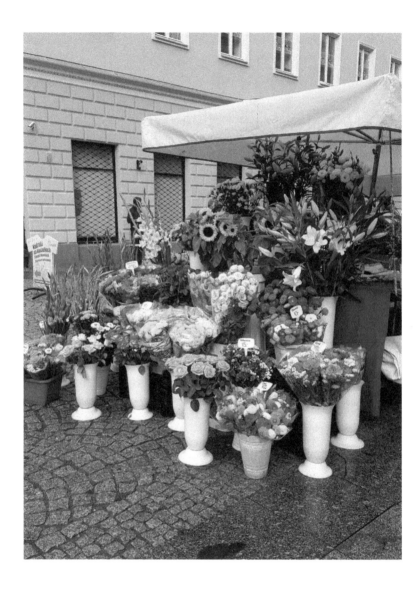

Europe is known for its flower stands. The colors are vibrant, the flowers plentiful, and they stand almost year-round, making passersby smile.
Who would you buy the flowers for?

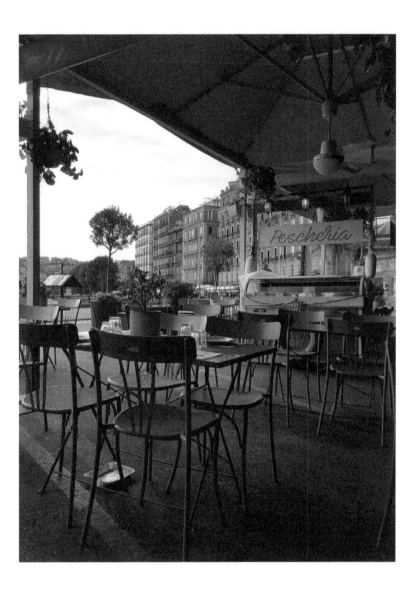

An outdoor café in Naples by the Mediterranean. Fresh fish, fresh pizza, and a glass of Italy's finest wine. What more could you possibly want?

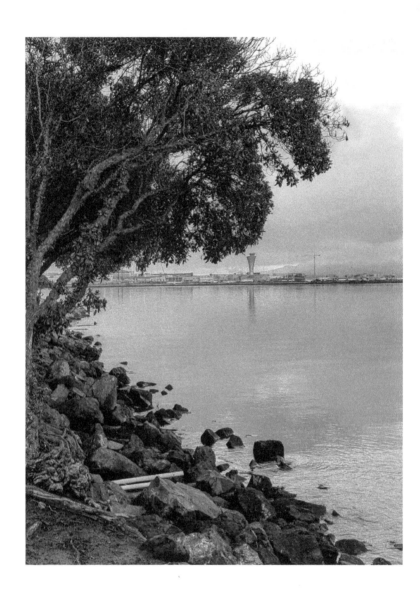

Way in the back, you can just make out the airport runway that ends in the Pacific ocean. If you could get on any plane, going anywhere in the world, where would that be?

So what does a one-eyed cat do all day when left to its own devices and a window that is cracked open just enough to easily squeeze through?

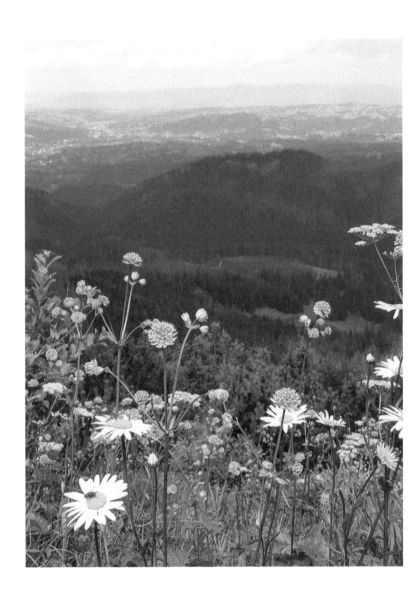

Mountain wildflowers and a quaint storybook village in the valley below. Write the opening paragraph (or more) to a children's story set in this picturesque place.

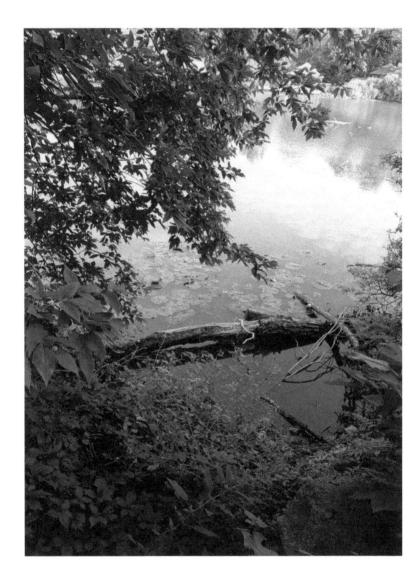

A break in the trees. Lily pads, croaking frogs, and possibly a fairy or two. What is this magical spot?

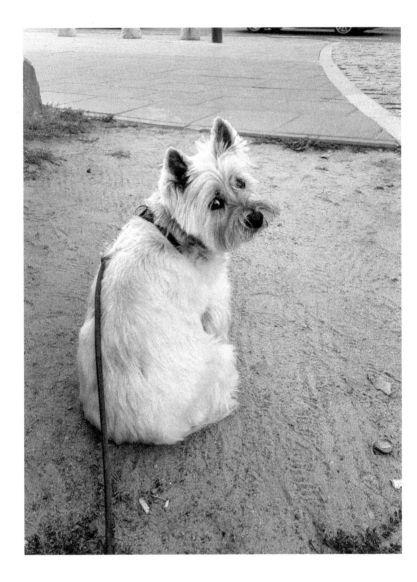

Where to next?

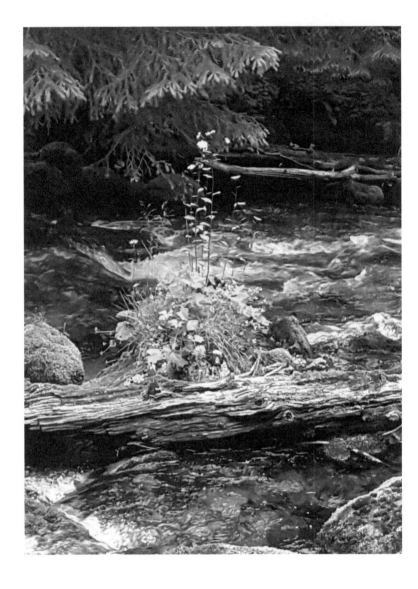

A perfect spot for a picnic lunch after a day of hiking. How good does it feel to dip your tired feet in a freezing mountain water stream?

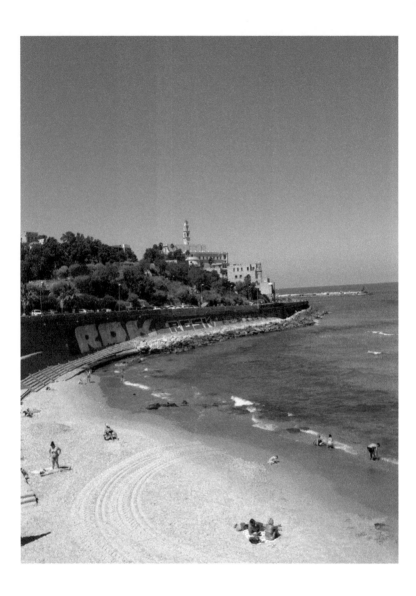

Behind you is the metropolitan city of Tel Aviv. You've been sightseeing all day and it is hot, only like it can get in the Middle East. What's the first thing you do when you see this tiny public beach and the crystal blue-green water?

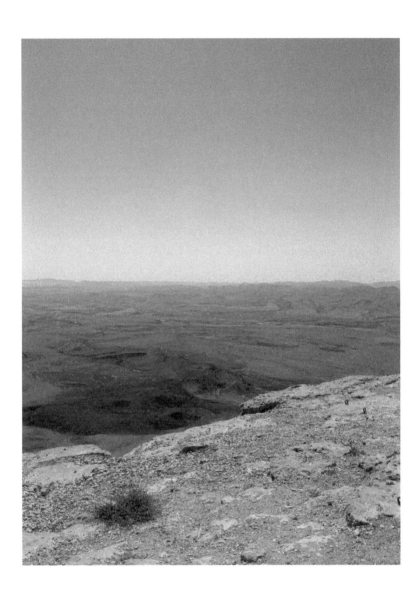

The Israeli desert. There is no reprieve from the beating sun. You look around, not able to see the awe-inspiring vistas, because you have no idea how you got here...

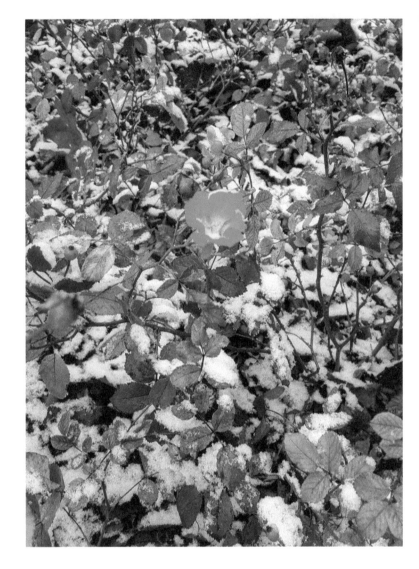

Against all odds, a lone flower survives the beginning
of winter. Using this scene as a back drop,
write a poem about perseverance and fortitude.

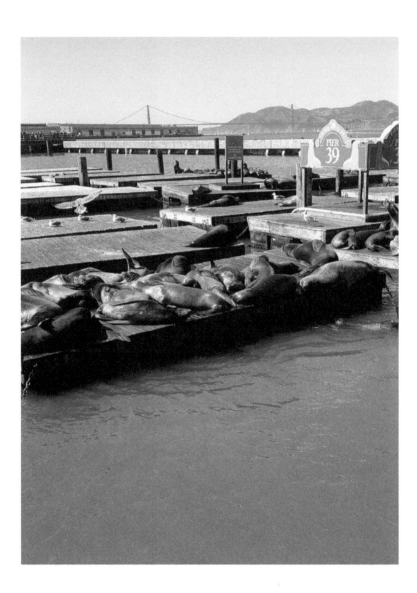

You may not have seen them in real life, but there's no doubt that you've heard of the sea lions that populate the docks in San Francisco. They are very loud and clearly having conversations with each other. What do you think they are saying?

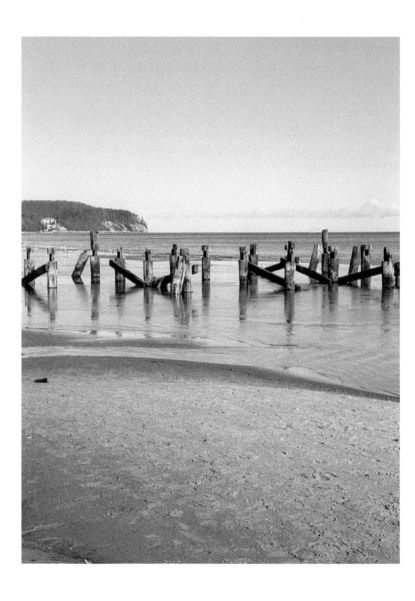

A beach during winter months holds its own special magic. It's much quieter and it's easier to be alone with your thoughts. Look around, see the water, smell the salty air, and hear the seagulls.
What are you thinking right now?

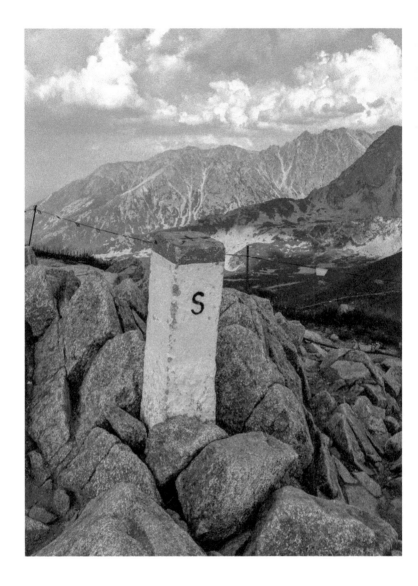

A mountain top marker dividing Poland from Slovakia. Years ago, there were signs warning tourists they would be shot if they crossed into Slovakia. The world has since changed and the signs are no longer there. Would you have dared to cross?

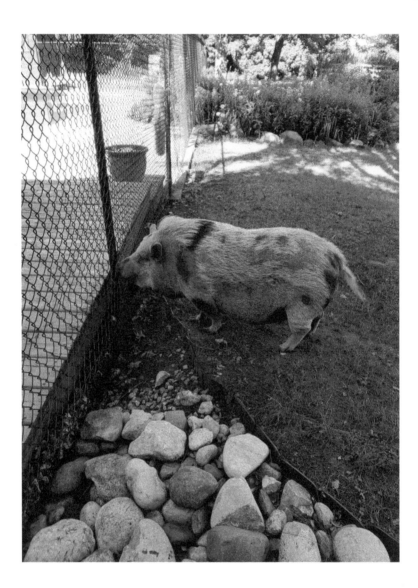

This is Kiwi. She loves potato chips.
Picture yourself walking her down the street.
How would you introduce her to people? Write a
conversation between you and a curious passerby.

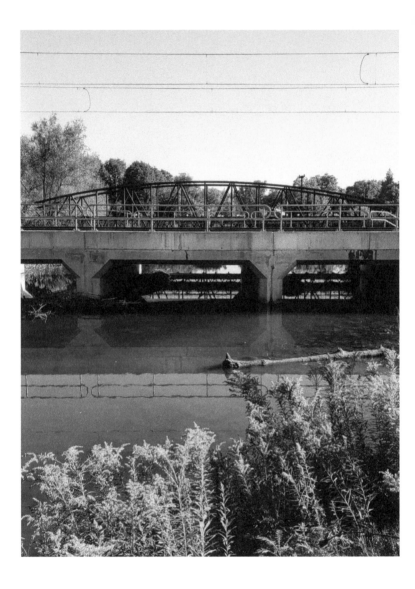

A bridge: a means of crossing a river,
or a path to a new world? You decide.

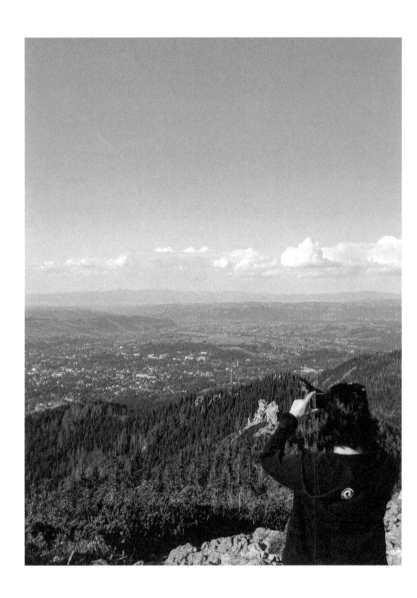

A photograph within a photograph. Close your eyes for a minute and picture yourself standing on the edge of a precipice. It feels like the whole world is at your feet. How are you feeling?

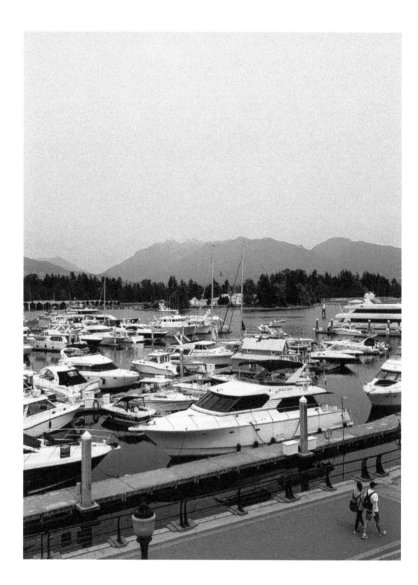

That big ship in the back is yours.
It is packed and ready.
Where are you going?

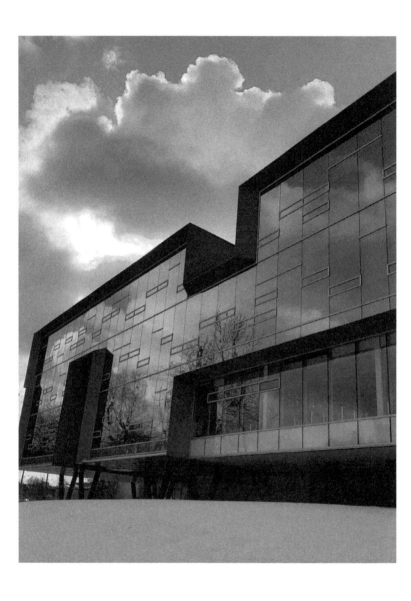

The facade reflects the seasons—summer, fall,
winter, spring—each one imprinted briefly
on the glass for everyone to see.
What happens on the inside?

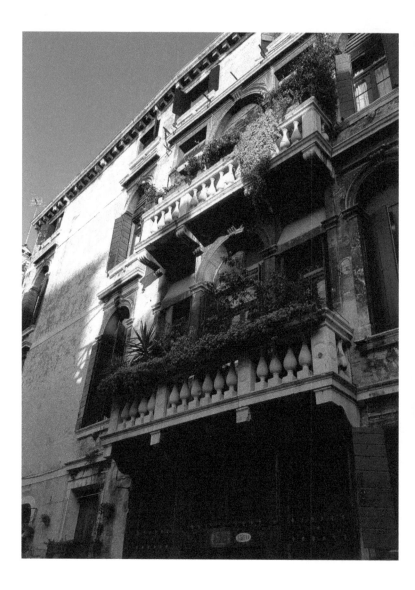

Many old European cities have narrow cobblestone streets which don't receive much light.
Only the top floors see the sun. Who lives here?
Describe a day in their life.

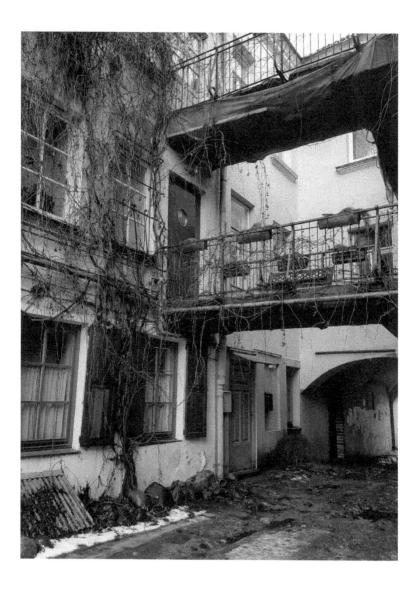

A rundown alleyway, or a place
where magical things happen? You tell me.

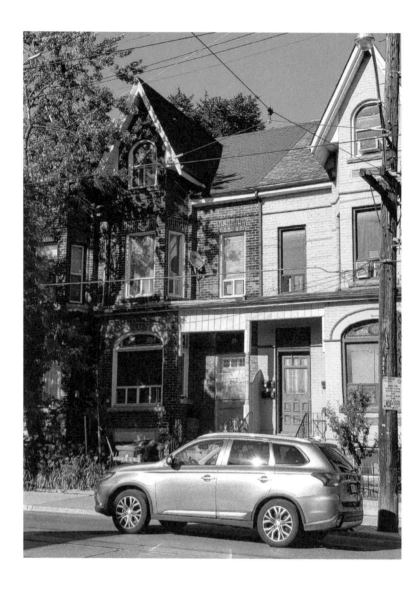

The blue house at the end of the street. You've walked by it hundreds of times. What is its story?

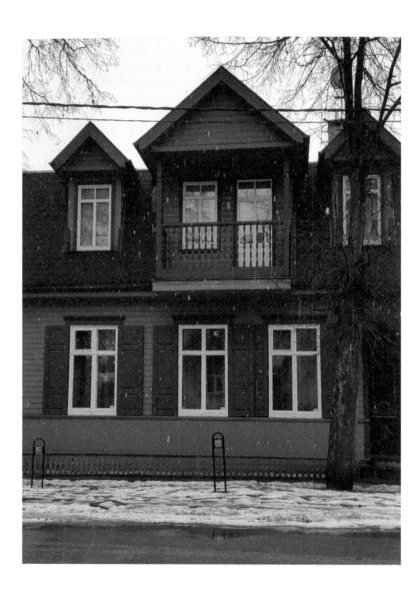

Lithuanian wooden houses make up a city within the city. Many are still heated by traditional wood stoves, some don't have tap water, and not every street is paved. Who are the people that choose to live here? Pick one family and describe their story.

Most American cities have huge, elaborate buildings that stand out architecturally from among their more modern peers. Their age usually makes them stand out. This one happens to be located in Pittsburgh. What do you think it has seen over the years?

A UNESCO world heritage castle. Which part of the castle is of the most interest to you?

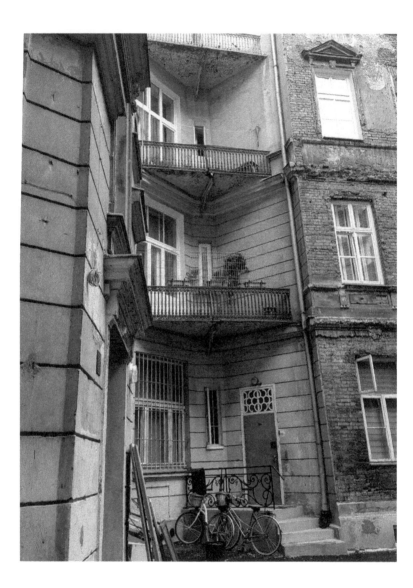

Although the building may appear rundown,
the apartments are actually luxurious.
How do you picture them looking?

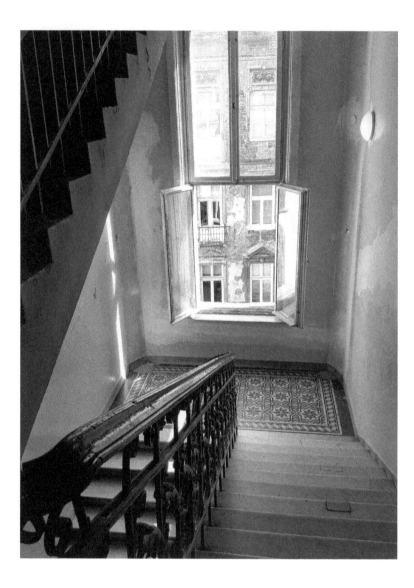

Pre-war tiles and stairs.
There is an elevator, but it's tiny and only big enough
for two people. Close your eyes and listen for the
families who have walked these halls.

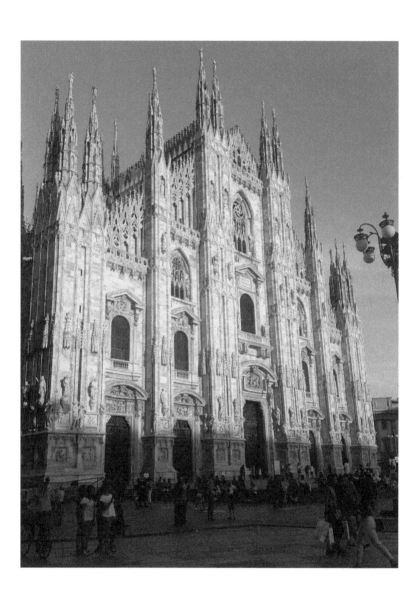

The Milan Duomo. Even if you have never stood in its shadow, you can still appreciate its majestic presence. How does it feel to look up at the intricate architecture basking in the sunlight?

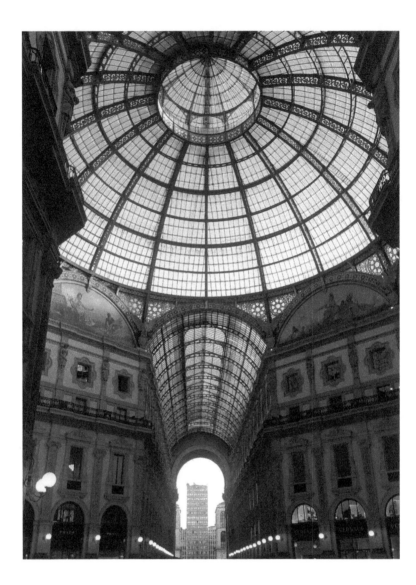

A luxury shopping mall,
an architectural dream, or both?

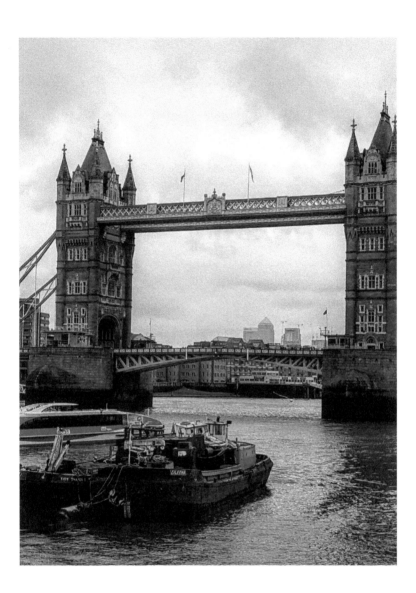

A London landmark, Tower Bridge, is an icon. How many movies have been shot here? Write the opening scene of a movie that would take place here.

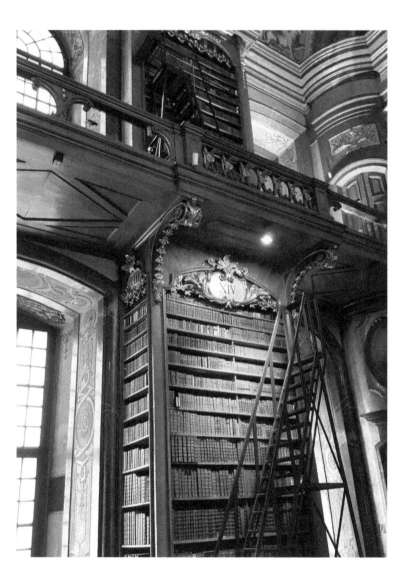

Part of the State Hall of the Austrian National Library. With old buildings, there's always more than meets the eye. What secrets are kept in these volumes?

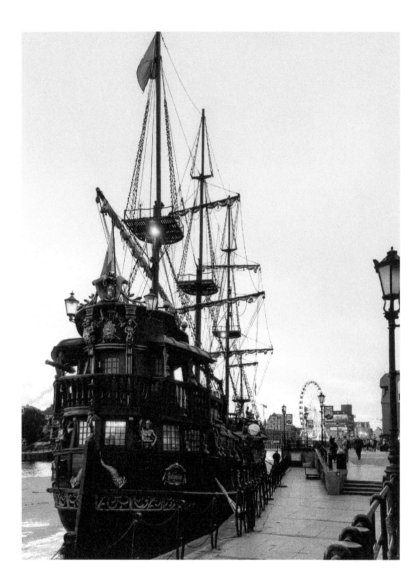

A pirate ship is just the thing to bring out the kid in
you. All modesty aside, what would you
do if you had the run of this ship?

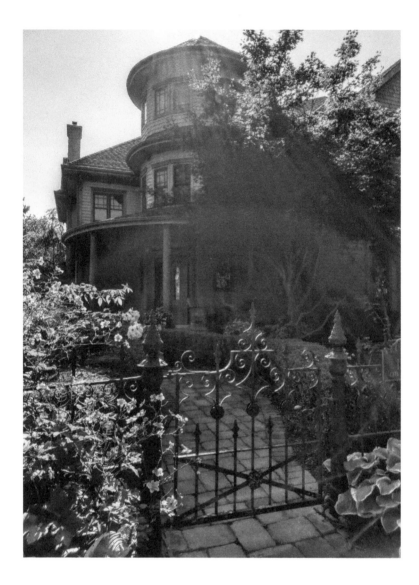

By day, this is an innocent old house. As soon as the sun sets, its floors begin to creak and the walls begin to talk. What happens after dark?

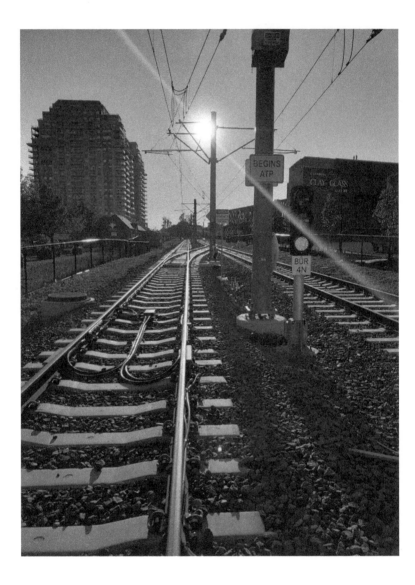

Train travel is a lot less popular now that we have cars and planes, but if you could buy a one-way ticket to anywhere, where would that be?

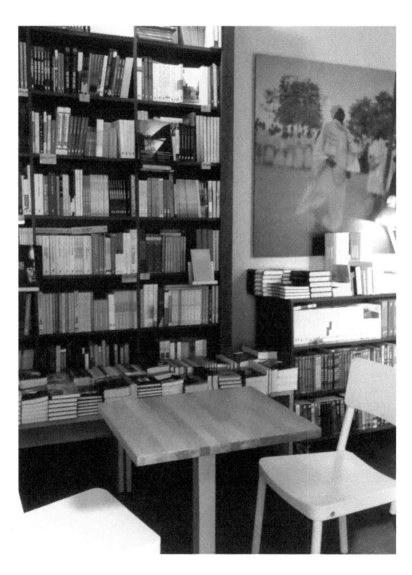

A classic bookstore/café. Who wouldn't want to see their book on display? This is your moment to let your imagination soar. Outline the book you have been dreaming of writing while picturing it right there on the shelf.

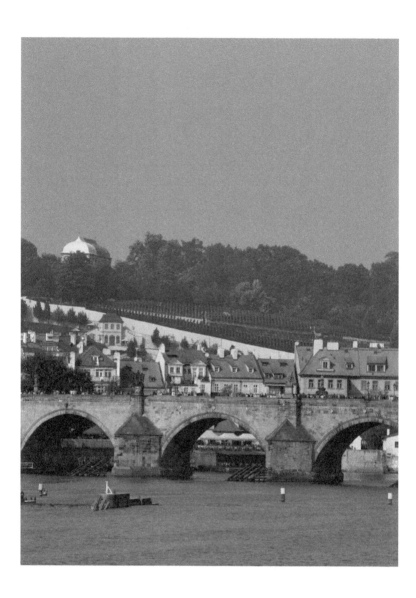

A city united by bridges. If this were a movie, it would probably blow up in a second. For the million or so people that call Prague home, this bridge is a part of everyday life. If you lived in a city that was hundreds of years old, would you notice its beauty or would you simply walk right by?

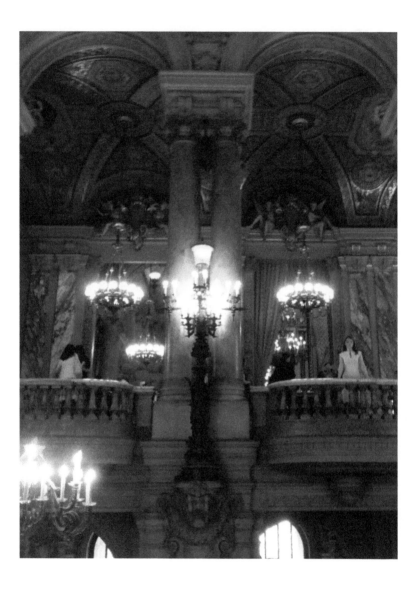

The Paris Opera Ballet. Who is the woman in yellow?

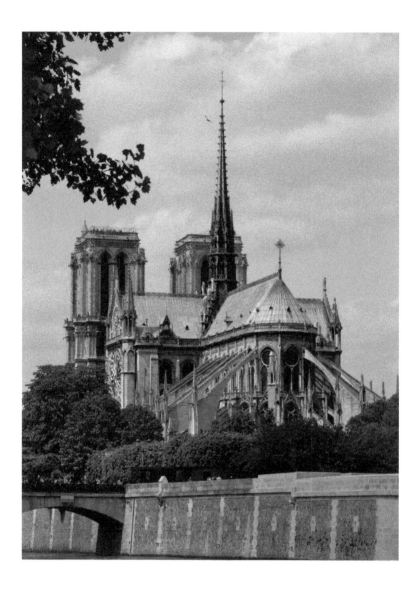

A postcard photo of the Notre Dame de Paris. Whether you are religious or not, there's a certain magic to old churches because they can't escape the history that has seeped into their stone walls. They have seen weddings, deaths, baptisms, wars, miracles. Pick one and create a story set in this storied building.

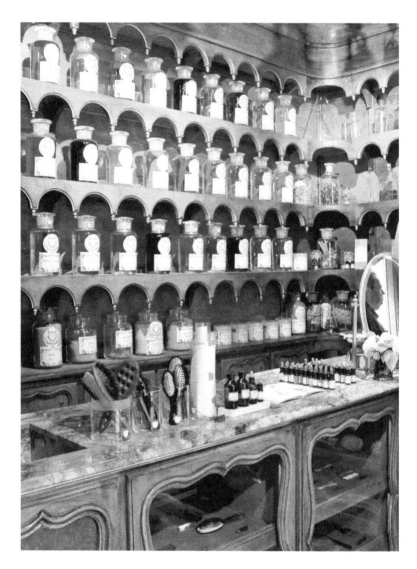

An old apothecary. Let's pretend for a minute that magic really exists and you've come in to collect oils for a potion. What are you making?

Just got discharged
from the psychward
today. — Fringey

This was on written on a wall at the park.
There has to be a story here...

Computer or handwriting? Pen or typewriter?
Everyone has their preferred method of writing,
but we all love a great pen and stationary store.
You have an unlimited budget.
What are you taking home with you?

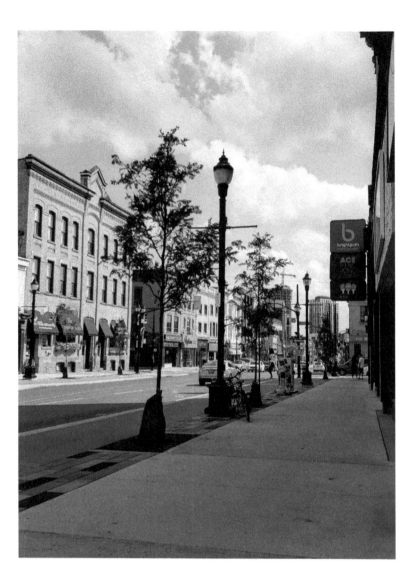

On a seemingly idyllic street, suddenly,
there is a loud crash...

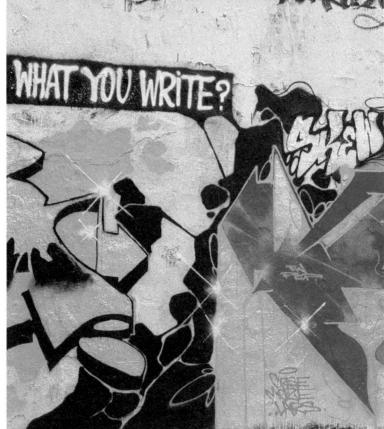

Graffiti can transform a drab
grey wall into a spectacular art show.
What words would you put on a wall?

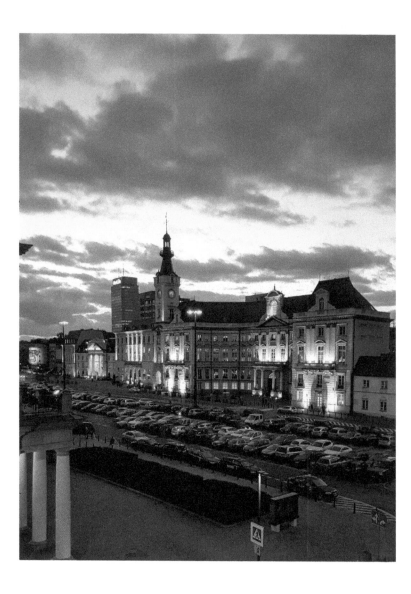

At night, the city comes alive, especially the theater district. Describe the scene. What are people wearing? What's playing?

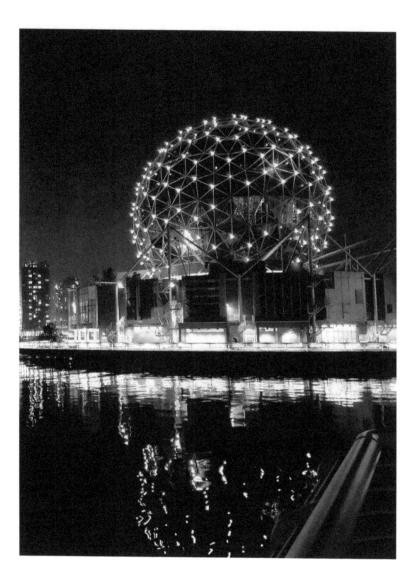

The seawall, the saltwater in the air, and the city spread out in front of you. There is a concert and the music is reverberating off the water.

How are you feeling right now?

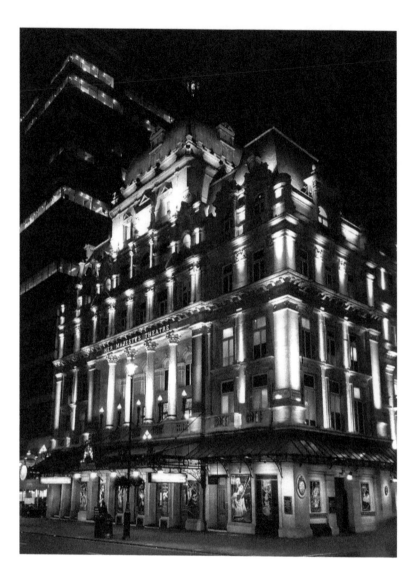

It's late night and the last theater patrons have left.
The streets are beginning to empty.
What happens after dark?

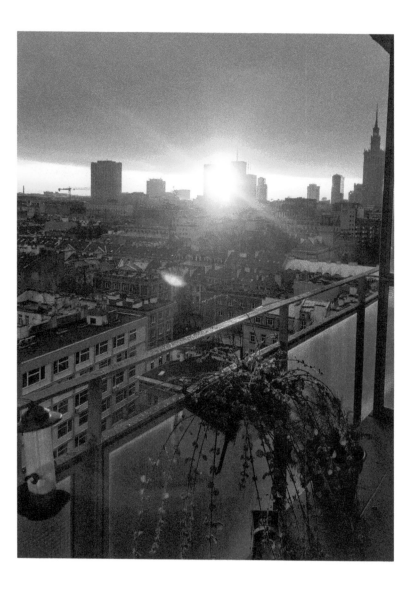

You are sitting on your balcony, enjoying unobstructed views of the city. The sun is low in the sky, it has been a long week. What are you thinking? How are you planning on spending your weekend?

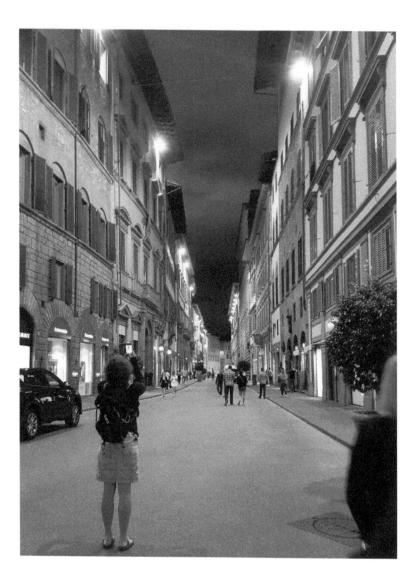

The perfect night sky juxtaposed with golden hued streets. It's nighttime in Florence, Italy. The streets sparkle with lights, the restaurants are filled with laughter and clinking glasses. What are you doing?

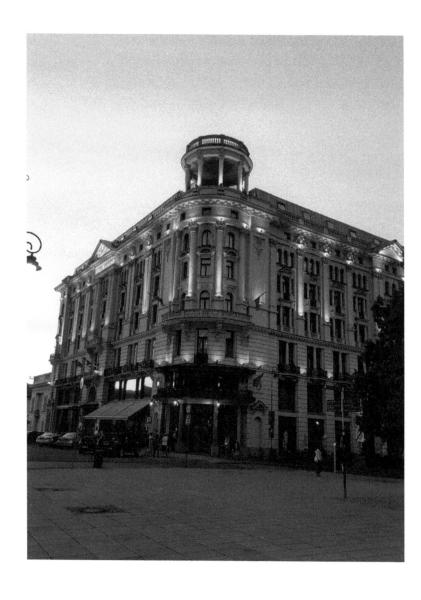

Hotel Bristol, a luxurious European chain. You can't quite see it, but a wedding party is about to spill out onto the street. Who are the newlyweds? What is their story? Are they happy?

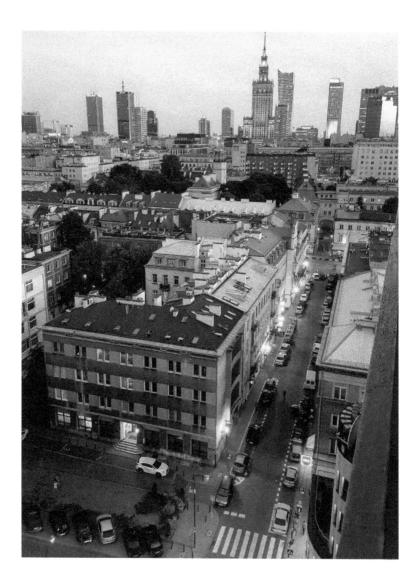

Friday night! It has been a long week
and the city is slowly coming to life.
What's happening on the street down below?

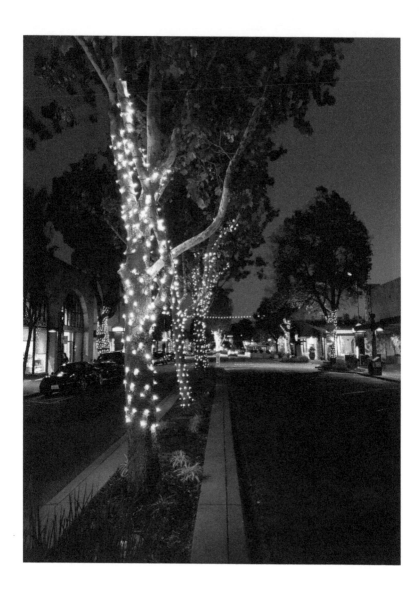

Silicon Valley is flat and spread out,
but every now and then, a charming area
sprouts up from the seemingly endless suburbs.
Tell me about this street and that shockingly blue sky.

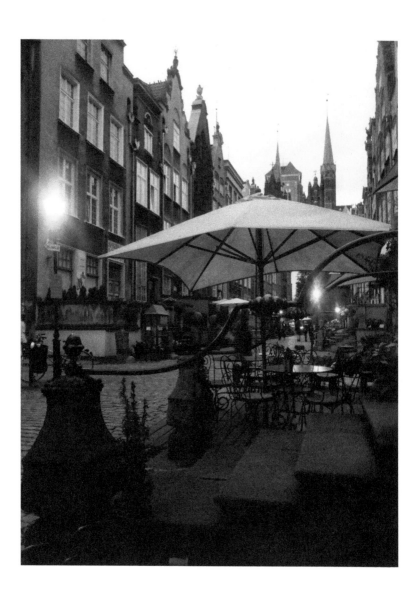

This spot is a writer's dream. You are on the Baltic Sea coast. There is an artist's café up the street. The stairs you see are original pre-war (the only part of this street that remained after the bombing) and, in a minute, hundreds of tourists will descend on this area. There will be good food, lots of music, and hearty laughter. Soak it in and write about it using as much imagery as you can.

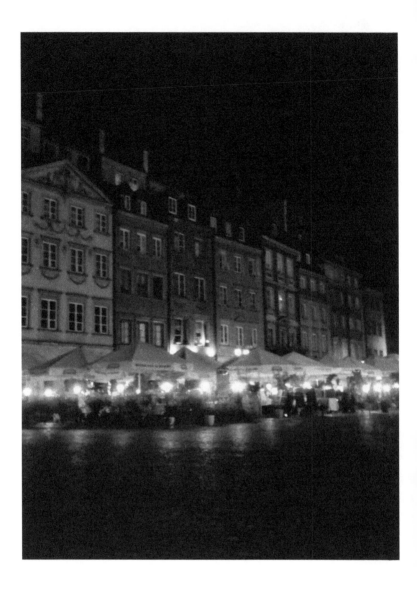

There is a party happening in Old Town. No, you don't get to skip it. This is about stepping out of your box and trying to write in a style you've never tried. This could be the scene for historical fiction, sci-fi, fantasy, or maybe even horror. You choose.

Caroline

Caroline Topperman is a European-Canadian writer, entrepreneur, dancer, and world traveler. Born in Sweden, raised in Canada, she finished film school with a BFA in screenwriting at York University in Toronto. While finishing her degree, she script-doctored an award-winning screenplay. More recently, Caroline spent four years living in Poland and is currently back in Canada. Caroline has a love of traveling and experiencing different cultures. She speaks fluent English, Polish, and French, and has even found a way to communicate with her playfully mischievous dog, Pixie.

Always a go-getter, Caroline has danced profes-sionally, owned a Pilates studio, where she trained pro-fessional athletes, Hollywood celebrities, and everyone in between. She has also consulted customers at beauty counters and even had a short stint at a car dealership. She isn't afraid to try something new and adventurous.

You can find more of her work on her blog:
StyleontheSide.com

CPSIA information can be obtained
at www.ICGtesting.com
Printed in the USA
BVHW06s0930251018
531139BV00007B/7/P